This Book Belongs to

Copyright © Eagle Eye Enterprise

For any inquiry, suggestions regarding our book
Contact at: info@eagle-eye-enterprise.com